P9-DSV-243

The Shimmering Beast

Steve Reinke

Coach House Books

Gallery 400, University of Illinois at Chicago

WhiteWalls Inc.

copyright © Steve Reinke, 2011
first edition

Copublished by Coach House Books, Gallery 400 UIC and WhiteWalls Inc.

Published in conjunction with the exhibition *Steve Reinke: The Tiny Ventriloquist*,
November 2–December 18, 2010, at Gallery 400, University of Illinois at Chicago

Published with the generous assistance of the Canada Council for the Arts and
the Ontario Arts Council. Coach House Books also acknowledges the support
of the Government of Canada through the Canada Book Fund.

Primary support for *The Tiny Ventriloquist* exhibition and partial support for *The
Shimmering Beast* provided by the Andy Warhol Foundation for the Visual Arts and
Gallery 400, College of Architecture and the Arts, UIC. Additional support from
Unnamed Future Space, Chicago; Impakt Foundation/City of Utrecht/Mondrian
Foundation; SAW Video, Ottawa; Canada Council Media Arts Commissioning
Program; National Library and Archives Canada; Birch Libralato, Toronto; and
Weinberg College/Art Theory & Practice, Northwestern University.

Gallery 400 is supported by the Andy Warhol Foundation for the Visual Arts;
the College of Architecture and the Arts, UIC; a grant from the Illinois Arts
Council, a state agency; and the Institute of Museum and Library Services, a
federal agency. The Daryl Gerber Stokols and Jeff Stokols Voices Series Fund
provides general support to Gallery 400 programs.

LIBRARY AND ARCHIVES CANADA CATALOGUING IN PUBLICATION

Reinke, Steve, 1963–
 The shimmering beast / Steve Reinke.

Co-published by: Gallery 400 UIC, White Walls Inc.
ISBN 978-1-55245-247-9. -- 978-0-945323-21-1 (White Walls Inc.)

 1. Art criticism. I. Gallery 400 II. Title.

N7475.R44 2011 701.18 C2011-901850-0

My Name is
Karlheinz
Stockhausen

This is the atomic age; the material itself must be part of the creative act. One no longer forms a given material, one must also create the material. We must make our own sounds, like plastic. The same thing's happening in the synthetic industry – they can now make any material from a few basic components and structures. And the great dream is that you can make different beings rise by going into the cell structure, by going into the nucleus. The discovery of the DNA code, for example, focuses on how you can create different species of being from scratch, starting from the very smallest particles and most basic forms.

You make a sound with an inner life because you want it to have a chance – not merely to survive, but to reproduce. To engender new sounds and states of being. You make a sound with an inner life because otherwise you're just mucking about the charnel house. You might be a chef, but you won't be an artist, a composer.

I wake up and I have entire pieces in me. I've heard them and remember them. My visions are sound visions. Synaesthetic visions, yes, but rooted in aurality. I've had very strong visions of a war between Russia and China, not in abstract thoughts but quite plainly vivid pictures, pictures with sound. And I've seen American cities being destroyed – not the ones you'd expect, but Cleveland, Minneapolis – America joining Russia in the big conflict, and then the Japanese, Iran. And then I see the aftermath, pictures of the

aftermath; purifying shock. I know these visions are visions of the future as the events have yet to occur.

You see, I finally felt strong enough to create a new world in which a known object doesn't become stronger than you. The great danger is that if you make a citation in music, in literature or in painting, and you quote something that, because it is old, is stronger, then there's a natural tendency for it to wipe out the new things, which you haven't heard or seen before – they're weak, you've seen them only once and so you can't remember them. You cannot grasp them; they will not enter you.

I can go into certain parts of my body, like a woman, like a cosmic woman. Sometimes I have a precise experience of my body's individual cells. It will take some time before I can penetrate the molecules and bring the electric juice that's me, the electric structure, into these molecular structures and conduct them the way I want, make them collaborate. I am sometimes already able to feel the precise moment when bacteria or viruses enter into me. I sometimes have trouble with my right ear – I've had moments when I could chase the viruses out of my ear. Literally chase them out. I felt the moment when they were leaving or when I killed them and they lay on the floor of my ear canal until they were swept out. I've gone to doctors and found out what these viruses were doing in me – reproducing, trying to change internal chemical structures – and I threw them out.

When I was sixteen I was in an ambulance crew that helped get the heavily wounded to the hospital. And I saw trees cluttered with pieces of human flesh after the strafing by the planes. And it's hard to imagine the sexual behaviour in the midst of dying bodies at the hospital. Dying makes you horny for death. The rows of slim white beds didn't help! I have no illusions about people who give up God but keep fucking.

After the war I worked as a pianist in bars. This was during the height of the black market. I collected cigarette butts when everyone left, made new cigarettes out of them, and traded them for butter. I have no illusions about the dark forces. The most evil people request the most sentimental songs. A title I could never use: *Music for the Next to Die.*

Think of the distribution of leaves on a tree. You could change the position of each of them and it wouldn't change the tree at all.

Kitchener–Berlin

Sure, art is long and life is short, but I am not troubled by this condition. What bothers me is that art is complex and I am simple, though conflicted: stupid. Art makes retards of us all. Writing about it is a clumsy thing, doomed to always miss what is most significant and instead gloss the petty. Criticism becomes an act of contrition, an extended apology. I am sorry – and sorry that this is the case.

FILM CONTRA VIDEO

Experimental video is centred around the voice: an individual talking, rhetorically deploying a particular subjectivity in relation to a certain construction of consciousness. Video is wilfully interior: its relation to the world is never direct, but processed through a particular subjectivity. It is doubly mediated, there is no direct perception, no immediate apprehension of the world. One cannot speak of phenomenology in relation to video without undue strain.

Experimental film has a completely different relation to voice and the world. There is no such thing as a 'personal' film. The voice in film always aspires to be the voice of God. Film is singly mediated, self-consciously authored by artists who retreat behind subjectivity to become merely thinking, perceiving bodies. Interiority is impossible, the world itself impinges too strongly.

Experimental video proceeds through a process of talking to one's self as if one had a self; experimental film

through a process of swallowing or incorporating the world into a self that is no longer human, but an author, a hollow signature attempting to structure perception.

DELEUZE

What I have learned from Deleuze: that there is a kind of vertiginous ecstasy to be always on the verge of coherency, to endlessly defer sense in the hope that what one approaches is something that had been previously unfathomable.

DREAM

I dreamt that I came across a book called *Kitchener–Berlin* and it was a really big book – lots of words, hardly any pictures, a few diagrams – something between an encyclopedia and an autobiography. It contained all the information about the images in the film – where they came from and what they mean.

This dream is partly a response to my hermeneutic anxiety – a feeling that I can't write about the film without a greater level of mastery, specifically the ability to form a reading that would proceed from an extensive knowledge of what is depicted in individual shots. So while I continue to remain resolute that *Kitchener–Berlin* does not call for that kind of interpretation (that is, will not constructively yield to a directly hermeneutical approach), perhaps its dream book does (and would). Perhaps this dream book is

a bible situated between artist and film and ready, in its encyclopedic detail, to tell us everything. We will study the book endlessly in order to derive increasingly accurate interpretations of the film. And the film itself – the hermetic, incorruptible art object – will sink into the background, a shimmering beast.

Life Without Life
(The Camels Are
More Human)

A particular event in Frank Cole's life serves as the impetus for two films: *A Life* and *Life Without Death*. This event, despite being repeatedly referred to, and depicted in both documentary and allegorical/symbolic fashion, remains sketchy, as sketchy as the biblical episode of Isaac and Abraham which it inverts. At his beloved grandfather's deathbed, Cole briefly entertains the possibility that he would like to switch places, that he would sacrifice his life to save his grandfather's. This thought so unsettles Cole, he declares he must never die.

How unsettling is this as a primal scene: the camera is already there, set up squarely at the foot of his grandfather's bed, pointing slightly upward so as to include the standing Cole, who splits his gaze between his grandfather and the camera. (But Cole's camera is always already there, anticipating every image, like Kubrick's camera. It isn't there to record, or to determine any kind of outcome or meaning, but to witness with an unflinching blankness, the vaguely diabolical anticipation of an unconcerned participant.)

God called on Abraham to sacrifice Isaac, but it was only a test. Kierkegaard, in the 'Exordium' to *Fear and Trembling*, retells the story in four versions: 1. Abraham turns wildly to Isaac and claims that it is his desire, and not God's, to kill him. Isaac pleads to God for mercy and is spared. Abraham claims: 'it is better that he believe me a monster than he should lose faith in you [God].' 2. Abraham is about to sacrifice Isaac, but then sees the ram God has left as a substitute and slaughters that instead. 'From that day henceforth, Abraham was old; he could not forget

that God had ordered him to do this. Isaac flourished as before, but Abraham's eyes were darkened, and he saw joy no more.' 3. Abraham begs God's forgiveness for the very fact that he had been willing to sacrifice his son. 4. Isaac sees Abraham draw the knife, and at that moment loses faith. 'Not a word is ever said of this in the world, and Isaac never talked to anyone about what he had seen, and Abraham did not expect that anyone had seen it.'

So, let's say Cole is Abraham and his grandfather is Isaac. (God is, of course, the camera.) *Pace* Kierkegaard, we could expand/interpret Cole's primal scene in various ways, but I find only one terribly convincing: a young man stands astride his beloved grandfather's deathbed. He imagines that if he could sacrifice himself and die in place of his grandfather, he would. He is immediately horrified by his willingness to sacrifice himself and vows to embrace life, a life without death. However, to embrace this life without death, he must first turn his back on his grandfather and disavow the (potentially sacrificial) love he had for his grandfather. At the risk of sounding trite: life without death is also life without life, though Cole remains oblivious to this fact and is doomed to blankly, unknowingly diminish life.

Cole's films are shaped as quests for greater self-understanding, though it is clear that none is really sought. Even the slightest glimmer of self-knowledge will not break through Cole's determination to survive himself. How could it? A death drive as narcissistically driven as this doesn't leave room for hobbies. His is a quest away from

subjectivity, away from life, away from love. Other possibilities: a spiritual quest, a geopolitical mapping, some kind of cross-cultural – or even cross-species – understanding. Well, it just doesn't happen. He goes through camels like tissues. (I'm exaggerating; actually, he goes through camels like handkerchiefs).

There is a type of purity here, a cinematic purity beyond, say, Herzog. The purity comes from an almost complete abnegation. These films are blinkered to everything but Cole's radiantly mute and narcissistic death drive. The images are blanks, without any interiority or master narratives. The end of *Life Without Death*, when Cole has accomplished his quest and sits on the beach looking at the sea, would be even more hollowly anticlimactic were it not for our foreknowledge that his unacknowledged, but painfully obvious, quest for death succeeded in his subsequent Saharan holiday.

But how beautiful are his images. How beautiful are his images of desiccated corpses. They are the only thing he will vacate the shot for.

Film is for fetishism; video, narcissism. That's just the way it is, the way it used to be. Fetishism requires some kind of scene, room to move about, yearning over time, a shape to the ceremonies. Bodies, objects, transformation. There's just no room for any of that in video. In video, you can look at yourself, whisper to yourself, lulled in a steady-state feedback loop. Cole brings the narcissistic interiority of video to film as he demonstrates that narcissism survives (filmic) death, is stronger than death.

The dead animals are fetishes. They are film. Every image, roughly speaking, is either a Cole image or a corpse image, which is to say, all the images are of a piece.

But the audio, Cole's audio, is decidedly filmic: the sounds are so very far away from the images. I'm always disturbed by the use of foleyed audio in otherwise documentary film. I wish it were inverted; I wish we listened to the world and made up whatever images we wished. Foley: two guys stand in a little closet manipulating rattles and bits of metal. They look through the little window and crumple paper as — on the large, silent screen — villages burn.

Cole's sparse deployment of audio is as masterful, as formally tight, as his use of the film medium. He's really (I may have failed to mention) quite good. His use of foleyed sound is judicious, except for one sequence: the makeshift surgery in the Sudan. I take this sequence to be significant; certainly it is an anomaly in an otherwise tight film. It is the only sustained sequence that has neither Cole images nor corpse images. But it does have images of a Caesarean section (inverted corpse image) accompanied by ridiculously intrusive sounds of wet sucking and sloshing. The overly loud sounds break the documentary veracity of what otherwise would have been a viscerally intense scene. This grotesque foley betrays a comically sadistic view of reproduction.

History of
Small Animals

I have killed my mother, my sister, my brother, and now I want to make my motives known. This is not a confession so much as an explanation. It will contain everything that anyone wants to know. I will stick to all relevant facts. I will not ramble.

In my early childhood I was very devout. I prayed all the time and saw God in everything and knew he could see me and was watching over me, that if I fell and cracked my head open on a rock my soul would float out and into the hands of my guardian angel who would deliver it directly to God. This was an idyllic time for me and I am told I often spoke non-stop, the joyous preschool babbling of someone learning his way around the language. My father tossed me in the air and always caught me on the way down, as I trusted he would. My mother would set me on her knee and bounce me up and down very quickly and for such a long time that I would puke. I would be hanging on her leg for fear of falling off and the puke would land on her clothes and for this I would get a spanking, or at least be screamed at and sent away. I would try to exit the room but, suffering still from dizziness and nausea, I would bump into things, coffee tables, door jambs, and the bumps were all over my still-hardening skull.

And then I was sent to school, kindergarten. My speech stopped. It wasn't my lips that were sealed but something deeper down, a constriction or hardening of the vocal cords that allowed only for little animal sounds to escape. But even this was not the real problem, it was that I could think of

nothing to say that could accomplish anything, I was trapped in a situation where my will was meaningless, useless to voice. I could think of nothing to say and no reason to say it. I decided to buckle down and learn to endure my difficult existence. I looked around and saw those around me having so much fun with little clapping games and finger paints, I felt betrayed, set apart by my superior consciousness. We would take out the crayons and everyone would draw the same picture: a yellow sun in a blue sky, a house on the green earth, smoking chimney, fir tree.

My soul hardened slowly, and I could feel it hardening; I could only hope that eventually from the constant and enormous pressures exerted on it a diamond or other precious gem would form in the centre and one day it would crack open and reveal itself, shining as if from some internal energy source. I imagined that they would find my dead body, pull it out of the river, cut it open and split the rock of my soul by hurling it against a larger rock, a boulder. Inside would be a little fossil like no one had seen before, it would be sent around to universities and museums that would finally conclude it was a wholly different kind of creature, completely separate from any established evolutionary chain.

I move from one thought to another with ease and a sense of completeness. Once, for instance, my topic was military battles. My interest remained more or less historical and was intended to be a prelude to learning how to play chess. I had a book about chess that contained all the rules, which

looked simple enough, but I was postponing taking up the game until I could locate another person willing to play with me. But I couldn't wait forever so I took up battle re-enactments in my grandmother's garden. The rows of tomato plants became lines of an advancing army, pressing forward to attack and to protect the villagers, carrots who could not pull themselves out of the earth to defend themselves. I swung a stick in a wide arc in front of me and smashed through the front lines, damaging many of my grandmother's tomatoes which were at the time almost ripe and ready for picking. Their juice soaked into the ground, leaving pulp and seeds all over the yard to take root and grow where something else was intended. My grandmother came upon this scene while I was lying near the cucumbers, panting heavily from the battle frenzy, and she quietly assessed the damage and turned around, headed back into her little house. Later on she shrugged and said: 'He loves to eat the tomatoes, they are his favourite, yet he mows them all down with a swinging stick.' But, this action completed, I was able to move on to a new and fresh thought and thus keep myself occupied in a constructive way. It was a school of my own making, self-study to replace the community school that had failed me.

My mother would call my father into the bathroom; she would be soaping her stomach or legs, and she would call for him to wash her back. He would wash her back and she would squirm, giggling, around, making the job take an extra long time. The bubbles in the bath would slowly

disappear, revealing those parts of her body that remained underwater, and she would slowly begin soaping the enormous and varied terrain of her body, hills and valleys. And this would arouse my father, she would see the bulge in his pants and tease him. She would arise from the bath, wrap herself in a very large and fluffy towel and retire to her room to read some trashy romance till she fell asleep. My father would watch TV for a while, then go to sleep or work. This happened not once but often.

I had a vision that the body of my mother was a large factory sitting on a chair beside a table piled high with quarters and she would with her right hand insert quarters into a nostril and with her left hand remove from a hole in her side little replicas of herself, which were stacked dangerously in little wooden boxes.

My father became night watchman at a lumber yard. But this job did not pay very well and he found that he arrived home very tired and vulnerable to my mother's complaints and ramblings. With her shrill voice she would withhold sleep from him till he was pale and very thin, with purple welts the shape of fingernail clippings under each eye. Then he would agree to do anything, and she held him screaming to his word, though he did not really remember what he had consented to anyway. It was on his good name she charged up hundreds and hundreds of dollars of bills for useless merchandise. She shopped while he slept and each day he awoke to the evening meal further in debt, though he did not know this, it was concealed from him. She burnt

the bills as they arrived, a Bic lighter over the kitchen sink. The smoke made him restless in his sleep and he dreamed that everything was burning and nothing could be saved. But these dreams were not exactly nightmares – they had a comforting aspect as well.

And me, I was getting older and discovering that as much as I liked to sleep and dream, I also liked to be awake and experiencing life as it unfolded in both nature and the human realm at all hours of the day and night.

Sometimes I would visit my father at the lumber yard – these were secret visits, I was as unseen as an angel. I would climb a huge maple that started just outside the fence but spread out and ended up largely over the fence, branches hanging into the yard. He would read news magazines, the best ones, *Time, Maclean's, Newsweek,* and doze softly while listening to talk shows or country music on the radio. He would make his rounds among the midnight stacks of lumber and sometimes stop to smoke a cigarette (which was against the rules, he kept the butts for later disposal) and stare casually into space through the fence. Once I heard him begin to sing a song very quietly, but he lapsed into humming as if he had forgotten the words or had no use for them. All around were the sounds of insects, which remind me of running water and power lines, and the tentative songs of birds, which remind all of us that dawn is soon though it may still be pitch black with the moon partly covered by clouds. I would be hidden in the tree, sitting on a long and sturdy branch so I could see into the office and all around the yard. My father would return to

the office and open the bottom drawer of the file cabinet which contained, underneath several obsolete files, a tiny pile of pornographic magazines. He would yank down his pants and flip through the magazines casually, knowing already which pictures pleased him. Then, having been denied any of the carnal pleasures a man can expect to enjoy with his wife, and not wanting to be unfaithful to her, he tossed himself off, quickly and efficiently, catching the semen from which I was fashioned in a kleenex and flushing it down the toilet.

I was always preoccupied with my excellence – I dreamed of glory, such were my daydreams. On my solitary walks I would make up stories in which I imagined myself to be some esteemed person, someone of money, prestige. I was constant in my attempts to enter into normalcy, to live in the company of others as they lived. Mostly it seemed a matter of saying the appropriate thing at the appropriate moment. It was with girls that I was the most obviously awkward; they took this as a tribute to their femininity and ran after me, trying to give me kisses. But so unappealing did they find me that if I did not run I was not pursued. And so I turned from friends of my own age group to those much younger than I, eight- or nine-year-olds impressed by the things I could show them and tell them. I took them on little nature hikes in groups of four or five. They found these trips exhilarating as I was considered slightly deranged – many of them were forbidden to associate with me. I had always thought of spending a sizable portion of my life inventing

and building the prototypes for original machines and useful contraptions, but it was the possibility of adulation by these youngsters that pushed me over that ledge of procrastination. The first was a machine to kill birds, and I named it the 'calibene.' I worked on it for quite some time, wanting it to be wholly original. I based my ideas on the forms of the birds themselves for it seemed nothing was more effective at killing a little bird than a big bird, though I had never seen this, only snakes eating frogs. The unhinging of the jaws, the elasticity of the belly plates – who would think something that can hop great distances would be so easily swallowed by something not even able to follow a straight line. My ideas were compromised and what I ended up with was little more than a modified slingshot, but my little gang was sufficiently impressed by this that I did not let on that I considered it an abysmal failure. They took turns using it and were disappointed that nothing was killed, a raccoon was hit and made to run and hide, but there was no blood and it did not die. My next invention was constructed more with my audience in mind than my personal satisfaction. I called it an 'albalester.' It was based on a description of a crossbow I found in a book, but the description was not sufficiently detailed and so it did not really work.

We had a pile of sticks to use as arrows, but when it became apparent the bows were dysfunctional the boys started using the arrows as javelins, soon complaining that they were not very effective and would never kill anything. I was worried that they would soon grow tired

of my company, that I was in danger of becoming less and less amusing to them, so next I invented a new form of crucifixion which I called 'enceepharation.' Frogs were the easiest to catch, so it was mostly frogs that I enceepharated. This new form of torture till death involved nailing them to a tree in such a manner that they might or might not be exposed to direct noonday sun. Three nails applied through the stomach, sometimes in straight line but most usually in a triangle, equal sides. Sprinkled with water or vinegar from a little plastic pouch, they lasted for several hours. The boys had wanted such death games and looked on in fascination, but soon my little tribe became disgusted. It was me who caught the frogs, I would not accept the ones they brought to me. And also me who handled the hammer and nails, and so their disgust, which might just have reasonably been turned inward to damn their own fascination at my murderous process, instead turned toward me and they became fearful of me, starting rumours that I might next enceepharate one of them. They did not find it comforting when I pointed out they were in general too large for genuine enceepharation – spikes would have to be used instead of nails, and even then, because it was imperative they go through the belly, the head and arms would loll and fall forward in an undignified manner, which I found unacceptable. It was meant, above all, to be a noble and beautiful process, partly inspired by the manner in which one is purified from rabies, daily needles into the stomach. I must add that my interest also crossed over into the realm of the scientific.

With a sharp knife, frogs slit open all along the white, mouth down to ass, where the green picks up again. Everything inside glistening and held together with tiny sheets of cellophane. Placing the little finger under the flap of chest skin to feel the heart still beating but slower and slower. I tried also to extract the brain but could find no method of opening the skull that did not mangle. Also noted was the existence of vocal cords. I rested my ear next to them but could hear no screams and decided the frequency was too high — I looked around for dogs who seemed agitated but found none.

The mother of my mother was growing sick and feeble and this was a triumph, for now my mother could always win any conflict without the sustained effort it had previously taken. *I only want what's mine*, she would say, *I only want to be treated fairly, and I don't care if it kills her.* And it did kill her, but not fast enough — it was a slow and eventual death. Every morning my Aunt Louise would stop by before work and prop her on the couch within easy reach of the telephone, the remote control, a few magazines and some food and water. The mother of my mother existed in this helpless state, fearing the erratic but frequent afternoon visits of my mother, Lucy. Lucy would ask if she wanted anything to eat, and if she unwisely requested something, my mother would be sure to botch the order, sometimes saying she was sorry she'd made a mistake and other times berating her mother for her unhealthy request and assuring her this substitute would make her

live longer. Then my mother would take the remote control and watch whatever she wanted, which was never what the mother of my mother would have watched. She would switch from channel to channel eating the snack she had prepared for my grandmother, and when this bored her she would survey the house for some precious object to steal.

This is what Lucy would say about the mother of my mother, words meant to destroy little by little by rendering something large smaller and smaller until it becomes so insignificant it is dead: *why wait for her to die, she has no use for any of these things anymore, she's senile and understands nothing, you wouldn't imagine what she asked me to fix her for lunch!* And in this way she managed to bypass the will and take for herself those things that rightfully should have gone to others. For this reason I was afraid to go to the funeral, I was embarrassed. My mother dressed us all, I was given new shoes, they were very shiny, and I lifted my eyes from them only once and that was to look into the coffin. I do not remember what I saw but it made me run out across town into some fields. My father tried to follow me, to console me, but my mother grasped him firmly by the arm and would not let him go.

This is how we came to acquire the plates and bowls I was ashamed to eat from, not to mention a lot of jewellery, a few hats (for my mother enjoyed dressing as a lady, not to go outside but to stand in front of the mirror and sway from side to side, laughing), a lamp and a tiny chest of drawers my mother referred to as precious antiques. Aunt Louise

was able to rescue the silverware, for it was too large for my mother to hide and it was clearly stated in the will who should get it.

My mother got pregnant again, there was no doubt it was from her husband even though their paths rarely crossed in the bedroom – the whole town knew my mother was crazy, dangerous, bad news all around, and so he would not touch her though she was not so bad looking, especially considering the condition of the women in town. Also, the baby, who turned out to be a boy and was somehow sensibly named Nathan, was a more or less exact duplication of my father, and turned out to be the kind of child a virtuous man would deserve. While I am antisocial with the kind of ideas that make it hard to get ahead in life, and my sister was becoming increasingly crazy like my mother, this child was of an even disposition and had no crazy ideas, or at least none strong enough to obscure the sensible ones fed into his tiny brain. And so this child would have undoubtedly turned out to be a success, a merit to his father and not an object of ridicule and pity.

And once my mother cooked my father's favourite meal, spaghetti with extra-large meatballs, and he came home and could smell it, his nose led him right into the kitchen smiling. Lucy was waiting for him. She was mad at him for some reason, believed she had suffered at his hand, and for retribution she took the pot of sauce and dumped it into the garbage, a garbage full of such disgusting objects it seemed unwise to salvage even a single meatball.

My sister was in league with my mother, that is why it seemed best to kill her as well. These are the reasons for slaughtering my little brother, whom I loved and who was wholly innocent: firstly, because he loved his mother and sister and would have mourned and misunderstood their deaths, turning perhaps into a madman in light of the facts, losing all innocent childishness and also adult sanity. Secondly, if I killed only the two, my father, though greatly horrified by the deed, might still take pity on me and feel sadness and regret at my incarcerated fate. I wanted to appear to him so contemptible he would have no regrets at my punishment.

I had meant to write out the equivalent of what I have written here, but with greater detail and smoothness and to mail this explanation, page after page, to the newspaper and also the school principal. I would have slipped it into the mail on some Saturday, killed them on Sunday, but I did not get around to composing it, all attempts were false starts, I could not concentrate my energies. Also, these pages were intended to serve as a suicide note, for I had planned to take myself as my fourth victim, as is customary, but in the end did not. Partly because I felt I must remain of this world to complete this writing, partly because I wanted to remain separate from those other corpses, and in this distinction make myself a truer object of contempt for my father.

My murderous plans were worked out in detail a full six to eight weeks before I had myself carry them out. This is

all I thought about during that time, whether lying in bed waiting for sleep or moving around during the day. I would like to say that these thoughts often kept me up for whole days at a time, that entire weeks passed without my head once buried under the pillow in restful slumbers, but it isn't true. By three or four a.m. I was usually fast asleep. When I dreamt, though, I dreamt of the freedom that would follow the slaughter, a freedom all sunlit fields and mossy ponds. I would eat only food I liked, in these post-family days, prepared the way I liked it, for I would be doing the cooking. My father would return home to me after a difficult but rewarding and lucrative day of work and dinner would be waiting, I would set it in front of him – all his favourite foods which are not so coincidentally my favourite foods – and we would eat in silence, the walls of our stomachs thick and pliable.

I want to say that visions flash through my mind as sudden revelations, as lightning flashes through the sky and sets or does not set the forest on fire so that animals run and try to take refuge in little ponds, but the heat is too intense and the water dries up and they are burned to death anyway. But my visions do not flash, I close my eyes and can play them in sequence, like an old-fashioned ViewMaster of the seven wonders of the world that gets stuck in trying to render photographically things that have long since perished and substitutes instead the Grand Canyon or sneaks in pictures of Mount Rushmore beside the Taj Mahal. In one my father is dragging my mother into the forest by her feet. She is on her back and it is raining very

heavily, her head swaying and moaning. He climbs a tree and pulls her up after him, keeps climbing and stopping to grab her ankles and hoist her behind. She is wearing a green dress but it is a very different green from anything in the forest and so she does not blend in, is unable to become part of nature. The dress is all wet and sticks to her body, she is scraped and bloody after being dragged for so long, but her hair is done up the fancy way, stacked and twisted and held in place by so many pins and so much lacquer that it remains immaculate. That is the image I have, it ends there. But this I think is the most probable conclusion: my father leaves her in the tree, climbs down and returns home, to listen to the radio, a distant baseball game all static as innocent players slide from base to base in an effort to create more statistics, more startling facts to help fill an empty world. In the morning she wakes up, the sky is blue and all around her, the sound of many songbirds comes from below. She yawns and stretches and begins to climb down. It is Sunday; the village has half a dozen churches, and the early services are about to begin. People are in their cars and driving to the church of their fathers in their specially ironed suits and dresses, black shoes. It takes her a few hours to climb down, it was the highest tree, but soon she arrives back home and looks in the mirror. She applies bandages and disinfectant wherever necessary – really the wounds are none too substantial, not very deep or long. She changes her dress and is ready for church, the second service is about to begin, and there is no need to do her hair, already it is perfect.

Finally, finally, this is how I killed them: I took a knife from the kitchen drawer, not the largest, which was monstrous and served, I think, no purpose, unless it was to hack open the occasional turnip, but the second largest, dull and gleaming. I held it casually, as if it were a favourite stone and walked with it up the stairs. Into my mother's room, but she was not there, she was in the bathroom, I heard the water running and the sound of her brush being pulled through her dry and brittle hair, pulling out the tangles. I sat at the edge of her bed and waited. I wondered if I should stand behind the door and surprise her with a series of hacking blows, but this seemed cowardly. I was not allowed in her room, it seemed impertinent to be sitting on the edge of her bed, the knife beside me, my fingers could see it and they sweated. The little nerve underneath my left eye began to twitch and I was reminded of the purplish welts that result from sleep disorders and lack of B-complex vitamins. And I thought that once more I would chicken out, would take the knife and walk out of this room and into my own, just down the hall. But then my mother emerged and it was too late, I was caught by Lucy in Lucy's room without an excuse, no excuse but the knife. I imagined her heart and aimed and thrust and was deflected by a rib. I thrust again and again, eight times in all, and in six of those the knife went in very deep, I twisted it like a bayonet. I didn't expect screams and there were no screams. I didn't expect blood and there was no blood. Lucy was empty, I had split open her heart and nothing came out, no sign of the

rumoured eight quarts. My sister was watching television, it was turned up very loud. I was thinking *spleen stomach pancreas* – I have some knowledge of how the body works and it seemed appropriate to remain in this case below the diaphragm.

But even as I was thinking this, the knife went to her upper body, heart, lungs, a number of thrusts and she was dead too. I knew when Lucy was dead, the exact collapsing moment, and stopped with the knife, but with my sister I continued on: two more thrusts. William was outside, playing in the gravelly driveway, bouncing a ball. 'William,' I said, 'come here.' He was not used to being called by that name, but he knew who I meant and he came to me. If he saw the blood – I myself neglected to notice, it was by this time covering me, soon flies would come, I would not notice the blood till I noticed the flies – if he saw this blood he gave no sign and climbed up on my lap as I motioned him to. I bent his head back, but this knife was no razor, I meant to slit his throat, ear to ear, let the brain be rid of all its blood, let it return to the trunk and the ground. The knife was too dull, I could not slice, I stabbed through the wind-pipe and the esophagus, he began to wheeze and bubble, but still seemed far from death. I stabbed through the bladder, the liver and the bottom of the right lung, I could not find his little heart and was tired of stabbing, my eyes were hot with tears, and I laid him on the ground, trusting death would follow shortly. I went upstairs and ran the bath. I took off my clothes and they fell into a pile by the bathtub. Then I went into my mother's bathroom and

I took a bottle of bath stuff made from seaweed which smelled very strange but was relaxing and made your skin smooth and shiny. I soaked for a while in the greeny water, very hot like I like it, so hot that you would get dizzy if for some reason you stood up quickly, if the phone rang or something like that, the doorbell. I had no plans for escape or for trying to hide my actions. I could not think of the future, could not even think of what I might like to eat next – it was the late afternoon and my mind should have been turning, on command from my growling stomach, to thoughts of food of some sort, in the shape of a chicken, in the shape of a carrot. I picked up my clothes, which were not so bloody after all, and carried them down to the basement and laid them on top of the clothes hamper. I didn't want it to appear that I was trying to hide any evidence, yet I didn't want to appear slovenly either, or like someone who would depend on some maternal force to do the laundry. Back upstairs I dressed for some reason in my Sunday best, my light grey suit which seemed so appropriate for the occasion. Polished my shoes, found the right socks, black, no pattern.

I was able to tie my tie on the first attempt and get it perfect, so calm was my state of mind at that moment, so deliberate my actions.

It seemed necessary that I leave this place forever, but I was not sure where to go. Luckily it was late spring and I would be able to sleep outside. I decided to take my sleeping bag, but wasn't sure what else to bring, I didn't want to load myself down. I decided I had better eat a good meal

before continuing on my way. I decided on spaghetti, high carbohydrates. We had a can of sauce in the cupboard and I put the water on to boil with a little salt. I opened up the can and noticed how bright the sun was coming in through the window. Summer is to me worse than winter, though in general I am against extremes and would prefer always a crisp autumn day. But the sun was direct on my brother's corpse, and I did not wish him to be found in a state of decay, so I dragged him to the other side of the house, which was still hidden from general view but would not receive direct sunlight until the next morning. His corpse looked very peaceful, I would have liked to strip him and wrap him in a white cotton or linen loin cloth and set him in one of the sumacs, but this was an idle thought, fanciful. I should have picked him up, though, and not dragged him. He was so light and the path very gravelly, but I did not want to soil my clothes with his childish blood. Back inside the water was boiling and I dropped in the spaghetti, just enough for one portion. The sauce I put on medium, then set the table. I ate very slowly, thinking what I should take with me on this camping trip that might last the rest of my life, hermit in the woods.

I took a knife, a needle, thread, aspirin, a plastic bottle, my wrist watch and a magnifying glass for starting fires and studying the movements and anatomy of small creatures such as insects. And I left. I did not bother under the circumstances to wash my dishes, but I did rinse them off and set them in the sink. I was going to cut straight through the bush, loop around the town, then head north

for the park. I decided, though, that matches or a lighter would be much better than the magnifying glass as far as igniting dry twigs and small logs, so decided to just walk through town to the variety store instead of skulking through people's backyards. I was expecting the woman at the counter to eye me suspiciously or at least make some comment about the sleeping bag, but she did not. Instead she said: 'Matches *and* a lighter, you must be planning on doing some heavy smoking.' At that point it occurred to me that one of the traditional things for me to do, in the event that I did not manage to kill myself, would have been to burn the house down. I felt silly for not thinking of it, but would not have been likely to do it even if I had. I walked through town and out of town, into the country. I could not decide whether to follow the river or the highway. The river led to lakes, the highway to another highway that led straight through the park, so I walked along the highway. I walked and walked. I walked a little ways into some bush lot, had a swallow of water from my bottle, rolled out the sleeping bag and slept with a rock as my pillow, a chunk of rounded granite. I dreamt of a ladder reaching from our backyard far into the sky, celestial and full of stars which did not twinkle but shone with a constant brightness. My father was holding the ladder and I was walking up it, first with the body of my mother, then the body of my sister, finally my small and gravel-stained brother. I do not wish to speculate where it was that I deposited their lifeless corpses. I awoke at dawn with hunger and the memory of eighteen dollars left in my pocket. Just down the road a mile

or a mile and half was a Dairy Queen, the kind that serves solid food as well as the usual frozen treats. I proceeded down the road and when I arrived it was closed, destined not to open until ten thirty. By my watch it was not even seven, but I am used to patience, it does not agitate me to have to wait, so I sat in the parking lot and waited, wishing I had brought with some paperback novel, some piece of classic and long-winded literature I had not until now had the attention span to plough through with enjoyment. At ten twenty a police car came and I was arrested.

They treated me very well, though they would not wait until the Dairy Queen opened, instead found me other food which I did not have to pay for. And thus ends this my history of small animals, me being the smallest, and most enduring.

Boy/Analysis
(After Melanie Klein's
Narrative of a Child Analysis)

FIRST SESSION

— I am afraid of school and the older boys and going outside and the bombs in the night and the war. Our greenhouse collapsed.

— Anything else?

— If I stand on my head all the blood will collect and I will die. And a tramp who will come in the night to kidnap my mother. I will scald him with water.

— The tramp is your father turned evil in the night. Also Hitler, a Hitler penis.

SECOND SESSION

— The sun will burn up the earth. Jupiter will be pulverized.

THIRD SESSION

— Switzerland, so small, encircled by Germany, will shoot down any plane. And Portugal and Gibraltar. The Germans will take Gibraltar.

— Daddy will put his genital into Mummy and it will get caught there, like the ships in the Mediterranean.

— I have discovered there is no happiness without tragedy.

— Not ambivalent, contradictory.

FOURTH SESSION

— We went to the zoo and I fed the monkeys. Nasty monkey jumped at me. Little monkey. Knocked off my cap. Greedy monkey.

— You are the monkey.

— Mandrill.

— Yes, mandrill.

— Always hungry, ungrateful.

— A baby, mouth wide open. Tore off his father's genital, little cloth cap.

FIFTH SESSION

— A puppy is a baby.

— Mummy could carry many litters in her belly. She's not too old.

— My dog eats coal and shits out coal, blacker still. If it bites me, I bite him. I move my jaws, open and close.

SIXTH SESSION

— The canaries are going bald. They have an illness. I have new socks.

— You want me to admire your genital.

— Romania is a lonely country.

— You want to put your genital in my genital.

SEVENTH SESSION

— How very small is Portugal.

— The map is upside-down.

— I would like the shape of Europe if Turkey and Russia were not there.

EIGHTH SESSION

— I had a nurse once.

— Old black car.

— I bit the nurse and she left, but she was going to leave anyway.

— Dead babies.

— They still bite.

NINTH SESSION

— Deciding between Estonia and Latvia.

— Little Latvia.

— Dusty stools.

— Rats.

— Face against the clock.

— Belly full of rats.

— Baby rats; no teeth.

— Genital ticking.

— Bad Hitler inside Germany.

— Austria.

TENTH SESSION

— Pencils, crayons, a pad of paper.

— I shall draw you a picture.

— Will it come from the unconscious?

— I'm using my hands. I want to make a lovely ship.

— And here in the water a starfish.

— Baby.

ELEVENTH SESSION

— Speaking of a tragedy.

— Speaking of a tragedy.

— Pleasure trip.

— Feeding frenzy.

— Octopus swastika.

— Little toy dog.

— Those fishes are whispering.

— Teasing the octopus.

— The babies are just jelly, not quite alive.

— The whole sea is Mummy.

— The boat, the portholes.

— She's looking out a porthole.

— She's waving.

— She knows what the fish are whispering.

— On deck they're shooting down planes. They've got an anti-aircraft gun.

— That's up above.

— I ran out of paper.

— Periscope.

— Dirty children take disease into the slum.

— The countryside is beautiful.

— Trains are always colliding.

— Touching the flag.

— Jagged metal.

FIFTEENTH SESSION

— They are all happy.

— They are all bleeding.

— That blood is bad blood.

— They're getting rid of it.

— Separating the bad from the good.

— Sweating it out.

— No wounds.

— Intact. Humming.

— Like taking a bath.

SIXTEENTH SESSION

— Uninjured beautiful external mother.

— Rolling hills.

— In an armoured car.

— The urge to leave.

— I broke the teacher's monocle.

SEVENTEENTH SESSION

— So many butterflies. Beautiful.

— They eat the cabbages. Destroy the garden.

— Butterflies are starfish.

— Underwater.

— Cabbages?

— For soup.

— Cabbages are cabbages.

EIGHTEENTH SESSION

— Three animals and two trucks.

— A problem.

— A cow, a horse, a sheep.

— A mathematical problem.

— Any combination will do. Any solution.

— They all get along.

— No wolf, no butcher.

NINETEENTH SESSION

— Sometimes you tell me secrets.

— But I don't say which things are the secret ones.

— Every train anticipates its collision.

— Not capable of putting his small (but undamaged) genital into such a vast genital.

— A woman can marry a chemical factory.

TWENTIETH SESSION

— A hen had her neck wrung and laid an egg.

— You want Daddy to give you a baby.

— I want to be a man.

— The Hitler penis will fill you with jelly.

— Starfish.

— Always hungry.

— The world is full of babies.

— Too many babies.

TWENTY-FIRST SESSION

— I was invited by the fishes to dine with them in the sea. I refused and their leader took offence and threatened me. I didn't care. I went to Munich. I was walking to Munich

and met Mummy and Daddy. They had bicycles and one for me. It was raining and a train came off the rails. It was on fire and the fire chased me. To get away I had to abandon Mummy and Daddy. The fire scorched the earth and I poured buckets of water on it until things could grow again.

TWENTY-SECOND SESSION
— I like the moon.
— Roughly scribbled circle.

TWENTY-THIRD SESSION
— Ether for the operations.
— Sinister voice, singing the German anthem.
— You know many songs.
— Hymns and nursery rhymes and anthems.
— National anthems.
— Humming at points, eyes closed.
— Points and portions.
— Tight.
— Tightly.

TWENTY-FOURTH SESSION
— Raining again.
— Cozy room.
— Dead people inside the living.
— All teeth.
— Beads.
— On a string.
— Necklace.

Clap.

— No more dreams.

— Nightmares?

— Empty sleep.

TWENTY-FIFTH SESSION

— Marching into Syria.

— Bombing objectives.

— Vending machine with a claw.

— I put a coin into the slot.

— Pocket of change.

— Here is a starfish baby for you.

— Little coins. Round and flat.

TWENTY-SIXTH SESSION

— Murder film.

— At the cinema.

— Stupid Mussolini.

— Broken genital.

— Winding the clock.

— Poor Daddy.

— Holiday after holiday.

— Marching and bombing.

— Piling stools.

TWENTY-EIGHTH SESSION

— Chocolate from the confectioners.

— Twisting red line.

— It is not Mummy's empire, it is an empire where all of

us have some countries.

— Pierced from the inside.

— Nothing falls out.

— Pears, toadstools.

— Feathers from the bottom of the cage.

— Canary.

— They are moulting.

— White acid lumps.

— Persecutory fear reduced.

— Depressive anxiety predominant.

TWENTY-NINTH SESSION

— Time to make more drawings.

— More hostile genitals.

— Starfish, mainly.

— I am very happy and I am very fond of you.

FINAL SESSION

— I have poison behind my nose. It will not kill me.

— What is that song?

— Squirrels.

— Birds.

— Shredded wheat.

— When the poison spreads, how can that be hypochondria.

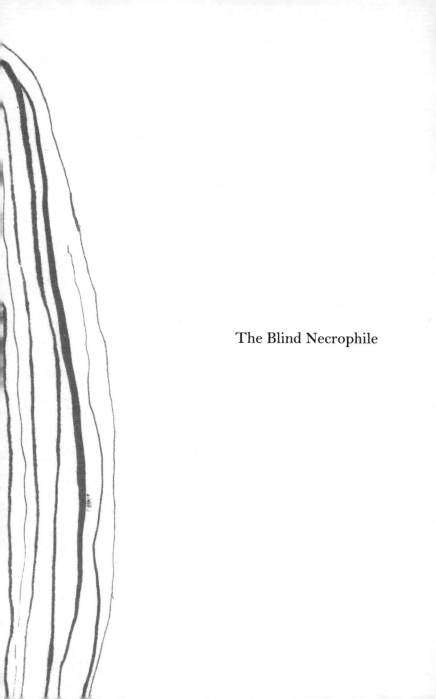

The Blind Necrophile

I was consulted by a blind man of thirty-two, G., previously analyzed for a short time by another physician.

The patient was born almost blind and at the age of four his eyes were removed. He was brought up in an institution for the blind, and although he received only a high school education, gave the impression of a person much above the average in education and intelligence.

He came for treatment because he was obsessed by the idea of killing someone in order to get a dead body. He liked very much the smells of perfumes, of grass, of flowers and of soil, chiefly because these smells stimulated his appetite for dead bodies.

This perverse craving began in early childhood, when he used to sneak away from the family and go into the cellar, where he would search for garbage, manure and dead mice and rats. As he grew older, he preferred to play with little girls because his blindness handicapped him in his competition with boys.

Early in boyhood he developed the habit of grasping little girls, kissing and hugging them. He soon knew that he wanted as much contact as possible. Hence, he selected those girls who were taller and stouter than himself, but as he frequently encountered a resistance to his advances, the thought occurred to him: 'If they were dead, they could not object to my company and my behaviour.'

He did not simply wish to kiss a girl; he followed a definite procedure: 'I would hold her tight, standing face to face. I would put my lips against hers, and would breathe in when she breathed out and vice versa.'

At a very early age he had dreams of finding dead female bodies in the cellar.

As he grew older, he had phantasies of fat tall women, either dying or dead, whom he could hug and kiss to his heart's content. His desire for hugging and kissing women became stronger and stronger in boyhood; he took every opportunity to hug his mother and sisters. They soon recognized or sensed that his behavior was abnormal.

When they repulsed him he would say, 'If you were dead, I could kiss and hug you as much as I liked and you could not refuse.'

When he matured and recognized his monstrous desire for dead girls and women, and the dangers that went with it, he displaced this desire to dead animals.

His description of what a dead woman would offer him reads like a gourmet's idea of a Lucullan feast. He dilated upon all delicacies of decayed flesh, how to cure it to bring out the odor, etc.; but as the smell of a human body would attract too much attention and subsequent discovery, he finally decided to be satisfied with a dead horse.

He at first knew no particular reason for selecting a horse; he thought, 'The bigger the animal, the more carrion; but where can one get a dead whale or elephant?' Moreover, the scream of the horse, like the scream of a woman, gives him a mixed feeling of fear and pleasure.

For many years the horse played the most important part in his phantasies. His great phantasy was to have a secluded farm and a horse, give it indigestion and finally kill it. The phantasies always revolve around a mare, which he

imagines 'mating with a stallion in order to get her pregnant and then kill her when she is about to foal.'

As the mare is a substitute for a woman, the following quotation is quite significant: 'I often think what fun it would be to see a baby horse lying on the breast of the dead mare and trying to drink milk. Then the body bursts open and the foal has all it wants to drink. I have also thought the same thing of a dead woman and a baby on her breast.'

His dreams are full of such wishes: he shoots a mother bear after she gives birth to her cub while the latter lies on her breast drinking milk. In his waking state he has phantasies of drinking milk directly from a cow's udder, to which he vaguely associates that when about three years of age he fooled around with cow's udders and was thrown down by the cow.

One of his frequent phantasies is to get a farm, starve or kill all the animals, and then indulge himself in the manner described with the remains of dead bodies. If caught, he would ask the court to punish him by confining him with a dead body until he died from the effects of the odor.

Without going any further, we can say that this patient's great need was to be able to wallow in the slimy carrion of dead female body. He was not only coprophilic, but also coprophagic; he often devoured horse manure and on occasion his own excrements.

In trying to put his phantasies in operation he thought of wallowing in a manure heap, but as this was impractical, he thought of filling up the bathtub with dough and

wallowing in it; but that, too, was not feasible and besides, he thought it unsatisfactory.

'I want the right kind of dirt, namely carrion. Anything else would simply increase my desire for carrion.'

In his distress he once made a full confession to his mother and she decided to help him: she proposed that he use a dead chicken and gave him one.

'It was put in a box in the closet, and I hoped it would soon decay and get the right odor. In order to hurry it, I mutilated the body and enjoyed the job very much! Wherever I went and whatever I did I had a lingering impression of the odour, which, while it pleased me, made me afraid that I would be discovered.'

As to his sexual activities, the patient stated that he accidentally discovered masturbation at the age of twelve and found that it relieved him from the desire for carrion.

He soon discovered, however, that masturbation was wrong, that it weakens, etc., and gave it up.

He never had any desire for coitus; he could not grasp it at all emotionally.

When his favourite sister discovered his horrible secret, she got the idea that all he needed was sex, and in order to cure him she offered herself to him. It was a failure.

The same thing happened when both a doctor and a friend to whom he confessed his perversion induced him to try a prostitute. What he actually craved was not genitality, but gratification of the olfactory, gustatory and tactile senses.

Instead of the normal integration of the senses, through partial repression and subjugation of the rest to the primacy

of the genital, the various senses here remained more or less on a childish level and functioned to a large degree independently, the sense of smell predominating.

The patient remained polymorphous perverse; he was largely dominated by his infantile sexuality.

However, he did make a strong effort towards object love, as I could readily see. Clinically, this patient could be designated as a case of necrophilia.

Death and
Sudden Death

The body of a woman was exhumed and a living child, who actually survived and grew up, was rescued from the coffin.

§

When the Opéra Comique burned down, twenty-nine bodies were found near the refreshment bar. They showed no marks of burning or violence; the dresses, and even the finest lace, were intact; these persons had succumbed to asphyxia by carbonic oxide. When their faces were cleansed of the black and grimy coating the smoke had deposited, three of them were found to be young girls. In the case of two of them, their relatives could scarcely believe they were dead when they saw them, for their complexions were rosy and the lips red. Even when putrefaction had set in, these girls still had a rosy look, because the red blood was propelled toward the head and face.

§

Josat invented a pair of forceps with claws, with which he proposed to pinch the nipples of persons whose death has to be ascertained. Josat obtained the first prize of the Academy, but Briquet, repeating the same tests on the hysterical subjects under his care, proved that they did not react under Josat's forceps any more than the dead.

§

It was affirmed that in persons dying suddenly, the eye preserved the impression of objects that were in front of it. Photographs of the retina of a person supposed to have been murdered were shown to the Society of Legal Medicine. It is said that these photographs reproduced the figures of a man and a dog in the act of springing and making the attack to which the individual had succumbed. These images, which were said to be so clear, were really extraordinarily vague. Many obstacles stand in the way of these experimental results ever having a practical use in forensic medicine; the subject must be killed rapidly, and the retina photographed immediately after death.

§

A young man called one day at a chemist's to ask for some strychnine to kill his cat. The chemist supplied him with the strychnine, but the young man changed his mind when he reached home, and no longer wished to kill the cat. Before shutting the strychnine in a drawer, he thought he would like to see what the powder tasted like, so he wet his finger, dipped it in the powder and licked it. He died in the midst of horrible convulsions.

§

When you put into your ear the finger of a living person, two noises can be heard distinctly, two slight rolling sounds produced by the muscular system. When these sounds disappear, the individual is dead.

§

You know what was called 'the Judgment of God'? When a corpse was found near a village, and it was impossible to detect the murderer, the inhabitants were made to file before it; if blood and gas escaped from the wounds, the person who stood before the body at that moment was arrested. That man, it was said, was the assassin, because the corpse revolted at the sight of him.

§

An individual hired a room with an adjoining dark closet, and suffocated himself in that closet. The owner of the house was not very much astonished at the disappearance of his lodger, but, seeing that he did not return, decided to let the room anew. The new lodger went into the little closet on the night of his arrival and found there the body of his predecessor. Death had taken place two months previously, and yet the body did not present any trace of putrefaction. It is true that it was winter, and that the temperature of the closet had always been low.

§

Of all the organs, the uterus putrefies last: for a long time after death its examination is capable of affording precise information. The body of a servant girl, eighteen years of age, was found at the bottom of a well. She was buried, but after more than a year had gone by, her master was suspected of having caused her to become pregnant and thrown her into the well. He was arrested; however, he denied it strenuously. An exhumation was ordered, and the uterus eighteen months after burial had still the shape of one that had never been impregnated. The accused man was acquitted.

§

Gentlemen, corpses exposed to the air or improperly buried are sometimes devoured by dogs, wolves or other carnivorous animals; you easily recognize this by the marks of their bites. But it sometimes happens that bodies, especially those of newly born infants, are eaten by rats. The bites of rats are sometimes difficult to recognize. They always attack the parts that are fat, i.e., the cheeks and heels; they divide the skin in a straight line, which often has the appearance of having been cut with a knife; so close is the resemblance that it is often difficult to avoid a mistake.

§

Two children died suddenly in a cold bath. In both these children the heart was so loaded with fat it was impossible to see the muscular fibre. They were like bags of fat.

§

A healthy woman was taken suddenly ill while walking in the street, and was removed to the hospital, where she died six hours afterwards. A large sewing needle had worked itself into the heart and caused fatal haemorrhage.

§

A dozen years ago, the body of a child was found under a heap of sacks on one of the quays in Paris. The child wore a scarf round its neck, with the ends waving behind. His companions had pulled the ends hard, so that the child was strangled, and then, being frightened at what they had done, they had hidden the body under the pile of sacks.

§

An old woman sold some snuff to a little urchin. While he was waiting for his screw of snuff, the boy, tickled by the sight of the old woman's Adam's apple moving up and down in her neck, struck her a blow on the larynx as if he were trying to catch a butterfly; the woman died instantaneously.

§

A girl complained of rheumatic pains. She was put to bed, and ten loaves of bread fresh from the oven were placed around her. At the end of three hours, the unfortunate girl was dead. She had succumbed to the hot vapours exhaled by the loaves of bread.

§

At Gloucester a boy, aged six, went home one day saying that he had been eating horse beans, and was found to be choking. He was sent to a doctor, but collapsed on the way, and died. Thirty-nine horse beans were found in his stomach, one was sticking in his larynx.

§

Allow me to remind you of a certain butcher boy, who imagined one night that his wife struck him on the head with a boot; he got up, took his knife and cut her throat, then he chopped her in half, as if she were a carcass of veal or pork, and set to work to cut her body into joints as if he were preparing meat for sale. He was arrested, and at the end of three weeks his alcoholic delirium had entirely disappeared.

§

It happened in a child twenty months old, whose father had just returned from work and gone to bed. The child began to cry. The father was out of temper, and went toward the child and said, 'Will you not be quiet, then, you ugly little monkey!' The child became silent, drew a deep breath and died immediately.

§

Toward the end of the Empire, an old lady was seized with uncontrollable vomiting.

Notes on
My Emigration

Has life in the American Midwest changed since the terrorist attacks of September 11? Probably. But I haven't been here long enough to know. Instead I'm continuing to trace a rupture in the mythical landscape of America that occurred about a decade ago.

God still operates here, but in a diminished capacity. Religion has been desecularized (personalized, corporatized). God was never really efficacious enough for the Americans anyway. Who needs mysterious ways? This is the land of direct action, concrete results. It's amazing He lasted this long. Still, one needs a higher power, an axis to orient personal growth, a lynchpin for twelve-step programs.

God's replacement: guardian angels. These angels aren't from the Bible, tiny, eternal satellites of God, rank upon rank, arcane and spooky. That would too old-fashioned. And they aren't really greeting-card angels, either. How can a Christmas tree ornament be a moral compass? Instead, these New Age angels are American loved ones. They have crossed over to the next realm (died) but still they can't stop talking.

These loved ones appear to Americans in dreams and visions, as well as through mediums such as John Edwards. I sometimes watch his syndicated daily TV show, *Crossing Over*. He comes out and says to the audience, 'I'm seeing a dog. Does anyone know of a dog who's passed? He's standing on a hill. He's standing on a hill and wagging his

tail.' Our dead always have the same three messages: *I forgive you, Everything is all right,* and *Everything will be all right.*

Clearly, spiritual life here has been reduced to hugs. But that's okay, as their main spiritual quest is the unearthing of childhood traumas, the discovery of repressed memories. Amazingly, it is a spirituality without faith, a spirituality with no discernible basis in the spiritual. The one bookstore in my Chicago yuppie neighbourhood carries only cookbooks, financial-planning books and self-help books in which the spiritual and psychological are blurred into a single goal-oriented blob of step-by-step instructions. Oprah seems to have something to do with many of the titles.

Follow your dead. Follow the trail of your dead, and their mumbling, insistent voices. Children are the future, but our dead are our history, our roots, our identity and heritage as suffering, incomplete consumers. We need to know what they have done to us and hidden from us, so we can move from these traumas with a sense of completion. Who needs God? Americans need to know who to blame and what to buy.

Americans had been unable to believe in the existence of terrorists. After all, none of them had discovered any repressed memories of terrorist abuse. They had focused instead on the more immediate and real threat of serial killers, alien abductors and Satanic ritual abusers. Perhaps

that is why the question asked most often in the immediate aftermath of the terrorist attacks was 'Why do they hate us?' and, amazingly, the only answer they could come up with was 'They are crazy jealous. Freedom-hating.' They never ask such questions of serial killers (they're sick, usually with excess creativity), alien abductors (they're just doing their jobs as scientists/earth-colonizers, both rational, sensible endeavours) or Satanic ritual abusers (they're pure evil, or possibly perpetuating the behaviour of their Satanic ritual abusers, which waters down the evil). This mythological landscape, I know, doesn't quite make a coherent system. But it does maintain the delicate, impossible balance between total solipsism and absolute conformity necessary for the American way of life.

Americans are nostalgic Utopianists, idle confessors: options not available to Canadians. Joseph Beuys said that every nation gets the artists it deserves, and AA Bronson has written that Canadian artists are bureaucrats. Canada is a nation of bureaucrats and educators. Occasionally our artists speak as bureaucrats and educators. More often we ironically displace the discourses of bureaucrats and educators into satire, parody, pastiche.

Autobiography is impossible in Canada. In America all confessors are heroes, as long as they don't leave out the juicy details. We are either annoyed or mortified and just want them to shut up. We find the supposedly heroic aspect of public confession silly, appalling. It is improper discourse.

The bureaucrat/educator can speak only as a representative, and then only with the aid of some kind of displacement.

Canadians never speak of love, for love is not an appropriate topic. But we do speak of death, and when we do, it is possible that bits of irony begin to leach out of the discourse. In England, as death approaches, irony increases. Irony there is rhetorical, something to be deployed. Irony here is more fundamental, constitutive. It is the life force of Canadian discourse. It's what we're made of.

Note on
My Immigration

So Chicago – all of Cook County, really – has a pretty good artists-in-the-classroom program that I was part of this year. They always have a shortage of people for the primary grades, so I happily went there, where the little humans are anyway more fresh. I wanted to be placed somewhere on the northside, maybe even here in Evanston, where I thought they'd have better crayons and stuff. But instead I got a southside posting. It turned out the crayons were fine there. Really, it's Crayola everywhere – they've kind of got a monopoly. Anyway, my plan was to get the kids to illustrate Nietzsche's *Thus Spoke Zarathustra*.

Just as Swift's *Gulliver's Travels* became, over the course of, say, 120 years, a book for children, so, I predict, will *Thus Spoke Zarathustra* be a children's book by 2040. None of his other books, obviously – just *Zarathustra*. So, in a way, I'm just trying to stay ahead of the curve. My plan was to take the children's drawings and animate them. It turned out, though, that they didn't really have the skill or patience for the kind of frame-by-frame pictorial consistency animation requires. And anyway, I was shut down before we could really start. I rescued only a single image, a single image I am not authorized to reproduce.

Camping
(On the Beach)

What makes a beach gay? The individual grains of sand are aware of themselves as scopophilic objects, self-consciously and rigourously inserted into a semiotic regime they may claim as their own. The individual grains of sand arrange themselves into pleasing tableaux, always aware, for example, of the impact of a striking diagonal against the rigidly horizontal horizon of sky against lake.

What makes a beach queer? There is no possibility of a queer beach, though autonomous pockets of queerness may establish themselves in any terrain. Queers hate diagonals and try to remain always at right angles: lumps arranged in irregular grids. A queer lump – never soft, never hard – will not agree to be a mute scopophilic object.

§

Gay time is dilated, like a sphincter is predisposed to be. In photojournalism and street photography (the documentary photographs of Doug Ischar's *Marginal Waters* are a kind of end-of-the-street photography) there is the 'decisive moment' that captures a specific occurrence at just the right time, at the apex of that event's narrative arc. But there are no gay events: gay life is not a softball game, or a war. It is episodic rather than narrative, but the episodes are static, without incident or development. There are no conflicts and no resolutions. Gay life does not reproduce. It merely endures. It is not a series of continuous actions but a sequence of discrete poses. (This is how Deleuze argues

the same point in his *Cinema* books: movies are gay, Hitchcock goes both ways.) Gay life has no conflicts, but is full of attractions and repulsions: one moves toward or away from something based on one's arbitrary, though highly refined, faculty of taste. Gay life, which often occurs largely in gay time, is a day at the beach.

When one attempts to narrativize gay life, one corrupts gay time, and nothing good can arise from the distortion. Case in point: Oscar Wilde's most unfortunate mistake, *The Picture of Dorian Gray*. In reality – gay reality – neither human nor portrait (between which there is very little difference) age at all. Wilde's attempt to narrativize the exquisite equipoise of flesh to painting produces distasteful results. The tragedy of *Picture*, of course, is that a perfectly acceptable painting is subjected to the heterosexual regime of teleological time and is thrown into bestial chaos, the night of all seething things.

Time is uncivilized; events are unnecessary.

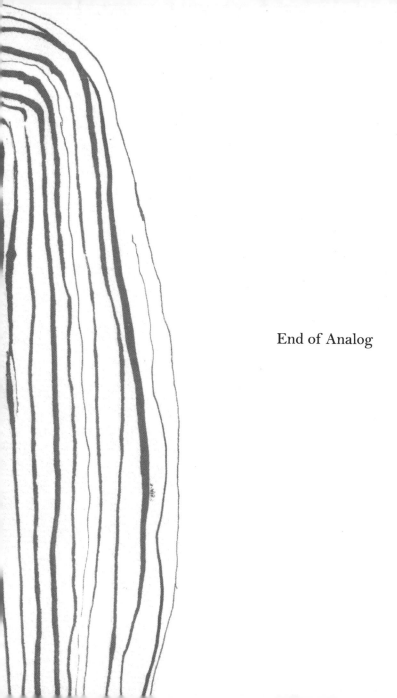

End of Analog

This is what I'm most looking forward to in digital television: the buffering and preload delay. Digital televisions need time before their highly compressed material (full of quantization noise, incorrect colour, blockiness and a blurred shimmering haze) loads. Channel surfing – that annoying *click click click* – will be a thing of the past. Now it will be more like channel sauntering, as it takes seconds – long seconds – for each digital channel to load. We will immediately become calmer and more satisfied. And television will be genteel, all rowdiness consigned to the internet. The change from analog to digital is analogous to the change from nomadic hunter gatherer to sedentary agrarian societies, and I, for one, am tired of all the roaming and clicking.

This is what I will miss about analog television: the snow and ghosting of a weak signal. Oh, there still be poor reception and signal loss in digital broadcast, but those systems have cliffs: when there is poor signal or a bit of interference, the screen will just go blank. I've read the specs: if you live close to the tower, a high-frequency signal will not make it through a bit of mist. It's all or nothing in the new digital world: data streams and pixels strangled by maximum compression schemes are not very forgiving. We will no longer be blessed by snowy television images (except as a kind of nostalgic digital effect, a third-party After Effects filter that is not quite convincing). And no ghosts. No ghosts and no ghost images. But there will be lovely echoes as televisions in adjacent rooms will have

slightly differing preload times: not 'other voices, other rooms,' but the 'same voices, other rooms,' warped and layered in an endless soothing round.

In Canada the digital conversion does not happen for a few more years, so those lucky enough to live by the border may be able to get some analog from up there. Canadian television is, of course, superior to American television as it contains more or less all of American television, plus some British shows. After the Canadian conversion (2012, scheduled to coincide with Ancient Mayan Doomsday) pirate analog broadcasters will come into existence. We are looking forward to contributing to this new medium, whatever it may be. Whatever it will be, it will have no flesh. It will be resolutely anti-corporeal. (Even Cronenberg has betrayed us: he is writing a novel.) No medium and no message. And – apart from one program completely devoted to Diet Pepsi/Mentos explosions – it will be nothing like YouTube.

Incidents
of Travel

We've been deposited by the Tennessee, a down-easter of 260 tons burden, turned out from one of those great factories where ships are built by the mile and chopped off to order. Her cargo: a heavy stratum of iron at the bottom; midway miscellanies, among which cotton, muskets and 200 barrels turpentine; on top, within hatchets' reach, 600 bags gunpowder. And us, gentleman adventurers.

The object of our adventure: ancient cities depleted to ruins.

Here is Dr. Cabot, of Boston, who has accompanied us as an amateur ornithologist. He can imitate birds, attract them with song, kill them and stuff them. He will soon learn that in this jungle, snakes have proliferated at the expense of birds, particularly the songbirds. Made conspicuous by their shrill instinctual calls, they have declined toward extinction.

And also Catherwood, of course: my constant fellow, a veteran explorer. I take it all down in words, he does the same in pictures, precise drawings.

But Catherwood's disembarked sick. His condition threatens to halt our travels even before they've started. He bloats for a few hours, puffing up like a bullfrog, then suddenly deflates. I do not imagine he will die of this; his body is much too volatile in fighting the thing off. He sweats and sweats and has left a residue of salt fringing the

bedclothes. We spoon him broth, he swallows feebly. I tell him, 'If you do not sit up soon, we will tie you to a mule.'

The earth is infested with malaria. The limestone is porous, like a sponge, too soft to be quarried. But Catherwood's not got malaria. Most likely a flat ribbon worm, some tropical parasite that migrates through the body burying eggs in lung and liver before lodging behind the eyes. And Catherwood must see! He is nothing but a pair of eyes attached to a pencil.

At dark we reach the house of Micaela. She has laid out food and prepared our beds. In the night I dream that Catherwood is laid across her lap, like Christ when a cross-stripped corpse, and suckles at a drooping teat. In morning Catherwood's fever has lifted.

The church is a blaze of light. Two rows of high candlesticks, eight or ten feet, extend from nave to altar. Innumerable lamps dot the whole space from floor to ceiling. On an elevated platform, an altar thirty feet high, rich with silver ornaments and vases of flowers, immense blooms that, on closer inspection, reveal themselves to be many minuscule ones gathered together. Priests in glittering vestments officiate before this gaudy altar, music swells through the corridor and arches, and the floor of this immense church is covered with women on their knees, dressed in white, with white shawls on their heads. Through the entire body of the church not a man is to be seen. Near us a bevy

of young girls, beautifully dressed, with dark eyes and hair adorned with flowers. The chant dies away and the women rise to their feet like the lifting of a white cloud, or spirits rising to a purer world. As they turn toward the door the horizon turns dusky with Indian faces.

A pie of cornmeal and pork. It is left under a tree to appease the spirits of the dead, but is instead stolen by the poorest of the villagers.

The roof of the church has fallen and light streams into the interior. The altars have been thrown down and the walls defaced. It is now a barracks. Near the door is a blacksmith's forge. Someone at the bellows, hammering a bar of iron into spikes. All along the floor half-naked Indians and brawny Mestizos hew timber, drive nails, carry on the business of making gun cases. The monks have been expelled and scattered, little mice burdened with beads and crucifixes. Near the altars had been floor vaults containing bones, but the vaults have been emptied, the bones scattered. No New World saints.

2

Do not suppose we are merely adventurers after antiquities. We have other operations at hand and are always occupied. We have with us a daguerrotype apparatus. We are becoming ladies' daguerrotype portrait takers. A new line for us, and rather venturesome, but not worse than the editor of

a newspaper turning steamboat captain. And besides, it is not like banking – we could not injure anyone by failure.

We made trials on ourselves till we tired of the subjects. They turned out tolerably well and we deemed ourselves sufficiently advanced to turn professional. As we intend to proceed with a love for the art, and not so much for lucre, we hold that we have every right to select our subjects. Our living quarters become the scene of an audition. We clear everything out of the hammock, take the wash basin off the chair, throw odds and ends into our one dim corner. We open our door and the sun pours in along with three young ladies and their respective papas and mamas. The young ladies are dressed in their prettiest costume, earrings and chains, hair plaits festooned with the tiniest of blooms, microscopic. All were pretty, and one exceptional – not in the style of dark Spanish beauty, but a delicate blonde, simple, natural and unaffected, beautiful without knowing it and only because she could not be otherwise.

Examine carefully the falling of the light on her face. Indispensable to turn the head with our own innocent hands. Adjustment of the scarf and chains. All clamped into place. Focus, then, the face in the glass of the camera obscura, the plate slides into the box. Now everything must be still for one minute and a half. No tremor of the lip or movement of the eye. But at length this eternity terminates and we slide the plate out of the box slot. Catherwood retires to the adjoining room and places the plate in a mercury bath.

Iodine bath, bromine bath – all salts and acids, the young lady's image is stamped upon the plate, making a picture that enchants all. Our experiments on the other ladies are equally successful and the morning glides away in this pleasant operation.

The next day falls to misfortune as all images refuse to etch themselves on the plate. The stubborn instrument seems bent on confounding us. We make more attempts the following day, intermittent tests over the weeks, but our technique is lost, and we give up the business.

We compare the resulting photograph to the lady in the flesh and find her already in decline, fading as all flesh fades and loosens from the bone. All becomes, all is, inevitably, alas, less grand and less stable than the image stamped chemically upon the plate.

A gentleman wishes to possess the image of a particular young lady. He will not speak to her, she must not know of his existence. It is not very easy to take such an image by stealth. However enduring an impression the young lady makes upon some substances, she can do nothing upon a silver plate. But the young man was fertile in expedients. We could easily make some excuse, he said, promising her something more perfect, and in two or three impressions, have one slipped away for him. A plausible suggestion, but we had qualms of conscience. The gentleman said he had a hunting dog, a sitter or pointer, and he would give it for the

portrait. We went to look at the dog, but it was a mere pup, entirely unbroken. All negotiations were called off.

It may not be easier to fall in love with an image than with a lady in the flesh, but it is certainly easier to be drawn into reverie and worship of her daguerrotype.

3

Let the people know that modern life is restless. The daguerrotype having failed, we have opened a surgery.

They have not heard of Guérin's cure for strabismus. *Squint eyes*, they are called, or *biscos*. They have their share of them, but none will go first. Finally a boy is put forward. Cabot opens his instrument case, calibrated tools from Paris, and finds despite all caution they are rusted. Catherwood brings out his razor hone and they work off the rust. The instruments gleam. The boy is fourteen, small, dignified, with large black eyes, one of which is turned in. There is a long table near the window and we spread the boy upon it. The eye is retained in its orbit by six muscles that adjust its position in the socket. One must sever the contracted muscle and allow the eye to fall into its proper orientation. This muscle lies under the surface, so it is necessary to break open the body, though only to the slightest extent. The boy lies quietly with his little hands folded across his breast. As the knife cuts through the muscle he gives a single animal groan, so piteous and heart-rending

it clears the room of all spectators. The boy rises from the table, eye in place, and walks home to his mother.

News of the successful operation spreads and now we have a gathering of squint eyes at our door. First upon the table, a strapping bisco, twenty or so, restless and cowardly. As the doctor cuts the muscle, suddenly and with a bellow the fellow jerks his head and shuts his eye upon the doctor's hook in a sort of lockjaw grip as if determined it should never come out. The handle sticks straight out and the lad wants to escape and live the rest of his days with this ocular protrusion, but the instrument is too valuable to be lost and we wrestle it out. Those remaining are more co-operative and we spend the day delicately hacking apart tiny recalcitrant muscles. They do not become easier, as I had imagined, but increasingly taxing. My head swims with visions of bleeding and mutilated eyes, but we have cured enough of the biscos and shall move to other endeavours.

Our luggage is sent forward on the backs of mules and Indians. The road is straight, level, uninteresting. We ride for an eternity.

4

A child is laid beside the church. There is no coffin. The body's wrapped in coloured tinsel, red and gold predominate, and amidst this finery worms several inches long issue from the nostrils, curling and twisting over the face.

A high mound appears a mere wooded hill, peculiar only in its regularity of shape. But there are four grand staircases, in ruins but ascendable, and we climb. The summit is a plain stone platform, fifteen feet square, completely unadorned. From here we see other mounds inconspicuous from a lower vantage point.

Not a full-fledged play, but a scenic representation performed at certain unspecified occasions. It is the time of conquest. Indians gather in a large place enclosed by poles. An old man rises and exhorts them to defend their country against the Spaniards. The Indians are roused, but in the midst of this a stranger enters in Spanish costume, armed with a musket. The sight of this stranger throws them into consternation. He fires the musket and they fall to the ground. He binds the chief and carries him off. The play is ended.

Fragments lie as they fell, forming a great mass of mortar.

This building was constructed of stone and blood, though now only stone remains. Up to the cornice, which runs round the entirety, the facade presents a smooth surface. Above is one solid mass of rich, complicated and elaborately sculptured ornaments forming a sort of arabesque. The grandest ornament, which imparts a richness to the whole affair, is over the centre doorway. Around the head of the central figure are rows of characters, which surely constitutute an unknown hieroglyphic language. Catherwood scrambles up and makes accurate drawings.

They believe these old buildings are haunted and all the ornaments become animated and walk at night. In the daytime they can do no harm, so the Indians take the opportunity to break and disfigure them.

Unmeaning fractional portions, but when slid into place have a symbolic meaning as part of a history, allegory, or fable. How utterly unprofitable to present a verbal description.

Here is a cave whose name may be translated as the *Labyrinth*, or *place in which one may be lost*. Despite its name and wonderful reputation, it has never been examined. Several persons have penetrated some small distance with the aid of string and returned verifying the universal belief that it contains passages without number and without end. I enter with a candle in one hand and a pistol in another. (I am apprehensive of startling some wild beast.) Twine is tied around my waist. No one will join me. Alone I discover that it is not endless but finite, not a cave but a building submerged in a mound. Not natural, not subterranean, merely buried. I will return in some future year and excavate.

In every mound an edifice. And a fire in every corner, to drive away the malaria. The flames light up the facade of the great palace and as they die away the full moon breaks upon its artful stone, mellowing its rends and fissures and presenting a scene mournfully beautiful and superior to sleep and dream.

Things coiled in other things. Essences, pure in themselves, but caught up in this other fabric so that they may be able to find themselves rooted in some kind of material existence, however contingent. Ravelling, unravelling, et cetera.

When it rains it pours but does not puddle. Evaporation occurs at the same rate as precipitation. The soil is thin and the bedrock spongy.

Underground swamps.

They dig only shallow graves, as if they were planting corn, and do not use coffins, but wrap their corpses in shawls. Here they are lowering a young woman into the dry earth. Her body is supported by ropes, her husband holds her head. Secure on the grave's floor, the shawl is opened and her arms, which had been folded across her chest for ease of transport, are laid at her sides. A white cotton dress, no shoes. Her hair is neat but unadorned. The shawl is again wrapped round. The husband arranges her head, places under it a thin pillow of white cotton. He brushes a handful of dirt over her face; others fill the grave, and they all go away.

Every day a bit further, until the horizon is breached.

5

They carry all their food uncooked in their bellies.

The disease is *cholera morbus*, attended with excessive swelling of stomach and intestines. A sheep is killed at the door and the stomach of the patient covered with flesh warm from the animal, which in a very few minutes becomes tainted and is removed. A new layer is applied. This continues until nine sheep have been killed and applied, and the inflammation subsides.

The house, like most in the village, consists of a single room rounded at each end. From the cross-poles hang a few tiny hammocks and in the middle stands a table, on which lies the body of a small child. It has on the same clothes as at the time of the accident, torn and stained with blood. On one side of the face the skin is scratched away from being dragged along the ground; the skull cracked; and there is a deep gash under the ear, oozing thick blood. It was a white child, three years old, who'd been playing about the house not many hours earlier. The mother's applying rags to stanch the flow of blood. A child, still soft-boned, is believed to be unstained by sin and flies directly to the side of God.

Strange heads and bodies lie scattered. Examining them carefully, we find two fragments that fit together to form a whole. A giant head and lumpen body, fissured at their jagged neck. A crouching human with a hideous expression and a headdress of a skinned wild beast.

Behind everything that is named, beneath the name of every thing, lies an older, truer name that can never be known.

My bones ache. A chill creeps over me. I look for a soft stone to lie upon, but the whole place is cold and damp and rain is threatening. I saddle my horse but can barely hold on. The horse intuits my condition and goes on a slow walk, stopping to nibble at every bush. Fever rises in me and I dismount and lie under a bush, but tiny insects drive me away by picking at my flesh. At length I reach my destination. We are groping in the dark. Since the hour of their desolation, these buildings have remained forgotten. We are the first to throw open the portals of their silent grave. Death's all around us. The spectacle's gloomy for sick men. A promiscuous assemblage of femurs and skulls.

The father passes in his robes. 'I am going for a corpse.' This is all he ever says. And the gravedigger, wiping his brow, says only, 'I am going to rest.' Or, 'My labours are ended.'

Pleasures tread lightly on the heels of death. Saints, flowers, tortillas. Where do the flowers come from? I've seen them growing nowhere.

The sight of the master fattens the horse.

6

The seasons alternate very frequently, and at irregular intervals.

A little dripping spigot hydrates the whole village.

An enormous iguana runs along the front of the building and plunges into a deep crevice over the door, burying the whole body, but leaving the long tail protruding. Such things are a table delicacy here, and the Indians begin to salivate in anticipation of a substantial evening meal. They tug at the tail, but cannot get the creature to budge. It has secured itself in an almost supernatural manner to this ruined building. Three men together, tugging in unison, snap the tail off at the root. It dangles in their hands, inert, a foot and a half long. Now the creature is completely within the wall, but it cannot escape. They pick away at the mortar to enlarge the sanctuary. They get the hind quarter clear and grasp it around the belly, but the creature adheres. They fasten it with ropes and tug and at length the creature slides out. They crack the spine and front legs, pry open the jaws and insert a sharp stick. The creature cannot run or bite, but alive, though marginally, will not rot in the sweltering day. They put it away in the leafy shade.

Dr. Cabot's sitting cross-legged in his hammock, dissecting a bird.

The caverns here are not simple, but multiform – opening always on lower and lower chambers. We follow an Indian, torch in hand, into a wild cavern which becomes thicker with darkness as we advance. After sixty paces the descent is precipitous and we go down a ladder about twenty feet. All light is lost, but soon we reach the bridge of a great perpendicular descent, to the very bottom, where a shaft of

light falling through some rough hole on the surface lands. We stand on the brink of this precipice. Gigantic stalactites and huge blocks of stone assume all manner of fantastic shapes and seem like the monstrous animal deities of this endless subterranean world. A ladder or staircase of rudest possible construction leads down, rough trunks of saplings lashed together lengthwise and supported all the way down by horizontal trunks braced and wedged against the face of precipitous rocks. It seems not secure, but each log holds. It's the Indians who have tended to slip and land crumpled at the bottom. There is no mechanism to remove them, and their skeletons, eventually, are swept to the side.

The first is named so that it ebbs and flows like the sea, receding with the south wind, increasing with the north-west. The second is not given a name; the third means *spring*; the fourth *darkness*; fifth *warmth*; sixth *milk*; seventh after a type of insect we have never seen.

7

Find letters from Catherwood home to his wife and son. He stockpiles them, unsealed, in anticipation of post. I had imagined he would speak of his daily concerns and adventures, vague impressions of a geographic, anthropologic, ornithologic, archaeological sort, but his concerns lie elsewhere. He speaks endlessly on grotesque and obscure subjects, dwelling on the insignificant and inappropriate. Would I quote from these missives at length, but they are

of a private nature, and would impugn his character and reputation. He is better served if they never reach their addressees, but that is no business of mine, so I leave them intact and undestroyed. I give you here only his naturalistic writings, which seem to me entirely hallucinatory.

Pitch pine. Fallen cones remain capped with stalks. If you cut the tree down it ignites easily and burns long. (It is full of pitch.) But a mature tree left standing will survive a forest fire. Everything else will burn to a smoking stump, but the pitch pine is unharmed and casually dispenses seed. After burns, pine seeds spill into the nearly cleared soil and germinate.

In the forest, a perpetual race for space and light (and water).

The cones stay sealed tight until a long dry spell or fire. Then the scales tilt open, and the cone becomes a full blooming flower of wood.

A smaller love, a higher calling. A symptom, completely isolated – no corresponding pathology.

Spring pocket mouse. A small thing, the size of a field mouse though extended into the world sensorily by a halo of fine, spiny hairs (like the whiskers of a most delicate cat) that sense all that brushes in the vicinity of a fine inch, an inch and a half: a leaf of grass, some insistent breeze, etc.

They are, socially, behaviourally, more complex than our regular mice. In some respects they resemble dogs. They live among wood: fallen trees, rotting stumps, that sort of thing. They burrow underneath the snaking toes of buttress roots. Smooth tunnel walls wind to individual dens padded with fragrant herbs and shredded grass. They come out at night. We hear them rustling. They roll little boulders of masticated leaf across their den's entrance to act as a plug. They defend their apartments with a low growl. In moments of escalating tension they drum the ground with a hind leg. If actively provoked, they lunge. They sniff out fruit and seed, dull insects and fungi from the forest floor, which is their floor too. Coffee beans do not agitate them, and they actively avoid that which is poisonous or otherwise distasteful. I captured four and kept them in a specimen cage. They will sooner starve than betray their preferences. I examined their bodies and found what I had earlier doubted was verifiably so: secondary cheeks. Fur-lined cul-de-sacs in which they transport food — hence the designation 'pocket.' With some trouble I insert an instrument. I find a tiny seed. Otherwise empty.

They reproduce with great frequency, six to eight litters a year, depending on rainfall. It is a great sight to see a mother giving birth to three or five pups in the moonlight, though the spectacle is hardly rare. In the days before birth, the mother constructs a little birthing nest in the open, twelve to fifteen feet away from her burrow's entrance. Here she sits, half reclining, on her back. In the hours

before dawn, grabbing with her teeth and forepaws, she pulls the pups from her birth canal and licks them clean. She eats the placenta, and if one of the newborns should be dead, or does not demonstrate significant activity, she eats it too. The young remain with their mother until they begin rivalrous squabbling – five to six days – at which point they separate and establish their own apartments.

Epiphytes. There exists a cloud forest. I have never been there. It is a delicate place, though not so very distant. Some take expeditions there, but they do not linger. It is no place for humans. The plants are voracious. They clamour for moisture and continually transform cloud to mountain rivulet. I presume all rivers, somehow, find their origins in such a process. The plants are cloud-destroying machines, but it seems new clouds migrate there knowingly, or unknowingly, as sailor to siren. Here dwell the epiphytes, elaborate, primitive but specific. They settle on other plants and use them as earth, as soil. These rootless ghosts masquerade as legitimate species: orchids, ferns, bromeliads. They are, however, merely epiphytes.

Squirrels. There are countless species of squirrels, beloved scourge. Benevolent vermin. One kind, small and reddish, clings to trees and trills like a bird.

Resplendent quetzal. At some point, there is very little difference between the mythical and the rare. The male quetzal is so dazzling no one has ever reported seeing a

female. In this respect, the resplendent quetzal is the most masculine of species. They drop backwards off branches when taking flight so as to not rake their tail feathers over the perch. As they plummet, rounded head and shoulders blur to one long, rippling body. They drop straight out of the sky like a spirit diving from heaven.

Allspice tree. All parts of the allspice exude cinnamon, nutmeg and clove. Remedies to create warmth and stimulate circulation. Boiled berries, crushed into paste, make a salve for rheumatic aches. Leaves for tea. In the case of the hermaphroditic allspice, the female produces most of the fruit and the male most of the oil, as well as copious amounts of pollen. The sweet and pulpy berry changes from an unripe green to a dark purple. The seasoning allspice comes from dried and crushed berries. All parts of the allspice are indeed beneficial medicinally; the trees sometimes die but rarely.

Ceiba. One tree they call the First Tree. None grows taller, or is more expansive. Many things live upon or about it. It is its own nation. It is their map of the universe. The umbrella of the upper branches is the heaven in which the upper gods dwell, irrelevant, temperamental.

8

Freed from the shadow of moral law, humans reproduce like animals. (Their women do not suffer pain upon childbirth.)

So little music, and so undeveloped, like an infant shaking its rattle, or a cat coughing up a ball of debris.

Nothing to be seen, nothing to be done.

I explain everything; Catherwood describes it. In tandem a meaningful picture emerges, a world apportioned, autonomous and independent of our will.

Learning slowly unknown things.

They let blood from their bodies.

9

We turn into a grove of orange trees and dismount. The trees are loaded and the ground is covered with the heavy fruit, but they are oranges of the sour kind and we cannot eat them. It is cool and fragrant in the heavy shade, but we cannot sit for the ground is teeming with nipping insects. Even standing we are obliged to switch them off with our riding whips. We mount and move on.

A dog disappears down the hole in one village and appears drowned three days hence, in the well two villages over.

Haunted by that which haunts us, and haunted by that which does not.

No words left but the words dripping off the pen. No voice words, no thought words, only ink words.

A cave, a stream, the deep shade of a single ancient tree; here sits an old woman with a serpent at her side. She sells water in small quantities, but not for money. She accepts only babies, which she feeds to the serpent. This old woman is the mother of the Dwarf.

Immense circular holes, sixty to two hundred feet in diameter with broken, rocky perpendicular sides from fifty to one hundred feet deep, and having at the bottom a great quantity of water of unknown depth: cenotes, supplied by the areas infernal network of subterranean canals.

They tied a pup to the clapper of a bell rope and put some food before him, though out of reach. There had been too much silence.

The worst kind of demon: *demonio parlero*, loquacious or talking devil, holding forth at night with all who wished, speaking like a parrot, answering questions, touching a guitar, playing the castanets, dancing and laughing without suffering himself to be seen. But if you strike him square in the face you will leave his nose redder than cochineal.

The demon has been slandered and weeps and complains, makes more noise than ever and is for a spell inconsolable. Then takes to burning houses, finding solace in the cinders.

We are invited into the cell of an octogenarian monk lying in his hammock, for many years unable to cross the threshold of his door, but in almost full exercise of his mental faculties. He tells us he has dug up many of the ruins on this island, and smashed and buried others, according to his taste and their comparative level of idolatry.

In the clearing is a dead tree, holding in its topmost branches the nest of a hawk of rare species. The dead branches are too brittle to ascend. We cut it down, but the eggs are broken, preserved only in fragments.

Not ornament but deformity.

Pinned into meaning by some ill-defined word.

Accidentally disinterred.

Rise like skeletons from the grave, wrapped in burial shrouds. Claim no affinity with the works of any known people, but a distinct, independent and separate existence.

The priest asks the child:
　　—In the afterworld, will you have everything you need?
　　—I will have everything.

Enter through one tunnel, exit through another.

Not Torn
(Asunder from
the Very Start)

If I say I dreamt these images and then found them in the archive, it is because I already had the images in my head, but not as memories. Memory and archive are fundamentally opposed, antagonistic. The affront of the archive is the assumption that it exists to redress memory's supposed flaws: its ephemeral nature, corporeal ties, fleeting subjectivities, gaps, mistakes, vested interests. The archive is not a repository of cultural memory but of dreams, a bank of dream material. The work of history is not memory work but dream work.

Both memory and archive embrace death, but from contrary positions. The archive is a mausoleum that pretends to be a vast garden. Memory is an irradiated zoo in which the various animals are mutating extravagantly and dying slowly.

My Life
(With Duke and
Battersby)

It has often been said that when an artist writes about another artist's work, he ends up writing about his own. And this seems more or less the case. At the very least, one ends up delineating one's own concerns under the guise of dealing with the other artist's work.

This doesn't bother me; I'm generally happy to write about my own work while presuming to write about another's. But not in this case. It would be too much, like staking a claim to some kind of ownership. So instead I'm just going to write about myself from the get-go, and anecdotally.

If spring is all tentative and weepy, this can be the mild winter of a history gone to slush. I don't know what there is to remember, or why to remember it. I do know that I don't remember much, though — not much of anything. This is why I keep making the same work over and over again, with slight unconscious improvements.

1

I first met Emily Vey Duke and Cooper Battersby in September of 1997, or possibly 1998. It was my first teaching job: visiting assistant professor of Visual Arts at the University of Western Ontario in London (Ontario). Emily was spending the year at Western. As was often the case, Emily was the enrolled one and Cooper was proximal, smiling. She was pursuing her bachelor's degree at NSCAD in

Halifax (then called the Nova Scotia College of Art and Design, now, ludicrously, NSCAD University). I'd just finished my master's at NSCAD three or four years earlier. I think Emily chose Western – an unlikely match! – largely because her friend Kim Dawn was completing her master's there.

Emily had enrolled in an introductory class taught by David Clark. I forget what it was called, but it included some photography (digital and analog) and audio and video production. Enrollment was large enough that we were splitting the class into two sections. David gave the students the choice of which section to join, and Emily chose mine. At first, she let on it was an uninvested choice, but really it was because she had seen my work at NSCAD.

They were mainly making little books then. I thought they were great. Emily didn't want to do the assignments, so I let her (them) do whatever she wanted. This caused some resentment among the other students. I would've let any of them do whatever they wanted too, but no one wanted to do anything in particular. Thus I was introduced to the first perturbing mystery of art school: students don't generally do anything in particular.

You can see some of the material from these little books adapted to the screen in their first video, *Rapt and Happy*: simple line drawings traced from snapshots, a line or two of dialogue/commentary/caption.

It must have been the next semester I taught a class in interactive multimedia (CD-ROM projects) using Director, software that could be used as a primitive animation tool – I'd been doing that for a few years. The animations in *Rapt and Happy* are simple enough – apart from the bubble that floats gorgeously between Cooper and Stephen (not this Stephen!) in the bathtub in the final scene, there is nothing here that one would really call 'animation' – mostly there are fades or cuts from one still image to another. Still, it seems to me productive to think of them as two-state animations, little thaumatropes with text.

I'm sure I can't claim to have taught them – Cooper, really – the software, as Cooper immediately surpassed me in any technical skill (in anything, sadly) I might attempt to teach him.

I don't remember any specific details about the making of *Rapt and Happy*. I remember Emily questioning me in detail about the precise meaning of a passage from Barthes' *Camera Lucida* and me being embarrassed I was coming up short. I remember seeing Emily curled up on a sofa outside the school's gallery and saying she looked so small, she was almost gone; but she did look small, and usually she was big.

Watching *Rapt and Happy* again, I was surprised to find I had put together one of the sections, 'FACES,' in which Emily, in a tight yellow T-shirt, sits on a red chair and makes grotesque faces for the camera. It was part of one of

a half-dozen shorts I made for Bravo called *Art Minutes*. (Although I was awarded BravoFact money to complete these, I never claimed it. Perhaps it is not too late to get the few hundred dollars from them.) Because the piece was meant for broadcast, I used copyright-free music, which worked fine. They kept it in.

I wasn't surprised to be impressed again by the strength of the writing in the longer monologues. I think it's incredibly fine: complex and nuanced, yet with an incredibly direct energy. The tone is perfectly balanced; the narrative is stripped bare, secondary to emotion; the humour crushes. Each word seems to me the right word.

What about Emily's ludicrously inept southern accent? (I remember that being an issue at the time.) Well, I think it works just fine. It is a slight gesture that moves us one step further away from the experience, a mediation that pales beside the masterfully cold post-presence of the writing. In Duke and Battersby's work, it is the force of the literary that marks all experience as retrospective: digested and shat or vomited, mourned and celebrated or execrated.

2

Around 2001, Emily came to study with me at the University of Illinois at Chicago. Cooper came with her, of course, but unofficially. He did not have a bachelor's degree and so did not initially apply for admission. But the faculty liked

their work (and Cooper) well enough to petition the graduate college to admit him the following year. The petition was successful, which resulted in Duke and Battersby having a three- rather than the usual two-year tenure.

Once they had me recite a long and not very funny joke about driving a car into a vagina and losing your keys. I liked the joke – it was one of mine although I no longer remember it. It was part of a work-in-progress they showed at a relatively early critique, a particularly scrappy work. I don't think anything was salvaged from it. I remember the joke being referred to as 'that misogynistic joke.' But the joke wasn't misogynist at all, merely a bit absurd. If it had been truly misogynist, I said, it would have been a lot funnier.

Their work was well liked at UIC, but I remember only the critiques that went wrong. Once, rather than showing work, they hired a yoga instructor to use their time to lead us through relaxation exercises. I found this stressful because I have to think a long time to distinguish between left and right and so by the time I figured out what limb to move where, we were on to another pose. Some others were not amused, viewing the gesture as a passive-aggressive *fuck you* to the critique process. I didn't care. At the time, I liked critiques but didn't see the harm in mixing it up a bit.

I asked Cooper to write a computer program that would take Emily Dickinson's concordance (which is online, and lists every word she ever used, along with frequency) and

use that data to determine which of the poems were the most and least idiosyncratic. He came back within the hour with the program: perhaps a dozen short lines of code. It seemed elegant to me. He also had the two poems. The idiosyncratic poem did indeed seem idiosyncratic – long and bad – while the most characteristic poem was just a bit boring. I've since lost the code and the poems and think I should ask Cooper to do it again. I'd still like to do a project that imagines Dickinson as a kind of nerve machine, an ecstatic computer, translating.

I asked Emily to recreate the drawings in Melanie Klein's *Narrative of a Child Analysis*, scan them and prepare the individual layers for animation. And she did a fine job. But I put the project on the shelf and did not complete it for several years. My video, *Boy/Analysis*, uses her drawings, but they are not animated.

I wrote a little text for an exhibition they had at YYZ, an artist-run space in Toronto that was, at the time, a very good place to show. The first line still seems to me to sum up one of the most interesting dynamics in their work: 'Empathy is a tool for making the cruelty more precise.'

Emily wanted me to love her more, to be demonstrative, devoted. But I remained cold. Emily encourages people to rush up and embrace me and then note my flinching discomfort. 'I didn't flinch at all that time,' I would say. 'Yes, you did,' she would reply. 'You flinched.'

I once told her that there was a difference between low self-esteem and regretting you are not omnipotent. This made Cooper laugh. But for Emily, there may actually be no difference.

Once I was getting rid of a lot of clothes and Cooper came over to get some stuff. Except for his dick, he's smaller than I am, but there was still some stuff for him. He considered a turtleneck, but Emily forbade it. 'You cannot wear a turtleneck! The turtleneck is the sign of the domesticated male.' So he took some T-shirts. Later, I would see him wearing one of them, and I didn't like it. *Why are you wearing my clothes,* I thought.

This is the question I've perhaps been asked most often about Duke and Battersby (maybe not so much lately, but in the old days): does it seem to me that Cooper is merely the technician fulfilling the 'vision' of Emily? The Captain to her Tennille? The George Bures Miller to her (gulp) Janet Cardiff? No, of course not. In the first place, there is no particular line between the technical and creative components of a video. And while Emily does do most (all?) of the writing, Cooper edits the stuff and is central to extending it through performance, animation, etc.

3

I went to Halifax to launch my book, *Everybody Loves Nothing*, at the Khyber. Emily was the director and Cooper was

the technician and, if I remember correctly, bartender. The launch went fine (though perhaps no books were sold). Later, at the bar, a guy came up to me. 'Your work is good,' he said to me. 'Pretty good. But I think it is mainly important as the progenitor to the truly great work of Duke and Battersby.' I smiled, which did not seem to be the response the fellow expected.

There's a short Duke Battersby work that doesn't seem to be in distribution, though they allow me to screen it. In fact, it is the work of theirs I've programmed most often. The title is horrible, but it's one of my favourites and I hope you get the chance to see it, over and over: *selfcentretarded*.

Afterword

I've already said what the shimmering beast is: those mute, hermetic aspects of an artwork that defy discursification. You approach them with language – to analyze, describe, interpret, praise, damn – and whatever you presumed you could grab on to recedes, incorruptible.

When I first tried to write about art (sometime in the distant 1980s), I could not think of anything to say. I would get other people – artists mostly, Barb Webb chiefly – to feed me the ideas, which I would then craft into the three or four paragraphs of a standard exhibition review.

Under the influence of Jeanne Randolph's writings on art – collected in such books as *Psychoanalysis and Synchronized Swimming* – I began producing texts for screenings, exhibitions and catalogues that combined elements of literature with criticism, a practice sometimes called ficto-criticism. Ficto-criticism claimed a collegial relationship with whatever art it was engaging with: not writing about, let alone judging or mastering, a particular work, but instead entering into a parallel dialogue. A critic cannot do ficto-criticism; only another artist can.

Take this book as a refusal to critically engage. Perhaps something like Sontag's call (in 'Against Interpretation') for an erotics, rather than a hermeneutics, of art.

Sometimes I attempt to apprehend the shimmering beast and say something about it. But more often I take some beast and make it shimmer. (On the screen I can sometimes take some shimmer and make it beast, but I have not been able to do this on the page yet.)

Making art is a strange business. I feel the pleasant gnawing of the necessity to tackle things from a variety of perspectives. All available means must be employed. (Chew or die.) Often, this desperate play has meant – for me – translating or remapping or reframing things. Something or some things.

Acknowledgements

'My Name is Karlheinz Stockhausen' is also the voiceover text used in my video *My Name is Karlheinz Stockhausen.* Vera Frenkel narrates. Inspiration was drawn from a variety of sources, perhaps predominantly from Jonathan Cott's *Stockhausen: Conversations with the Composer* (Picador, 1974).

'Kitchener-Berlin' was written for *Landscape with Shipwreck: First Person Cinema and the Films of Philip Hoffman,* edited by Mike Hoolboom and Karen Sandlos (Insomniac Press, 2001).

'Life Without Life (The Camels Are More Human)' was written for *Life Without Death: The Cinema of Frank Cole,* edited by Mike Hoolboom and Tom McSorley (Canadian Film Institute, 2009).

'History of Small Animals' revisits the confession of Pierre Rivière, best known from Michel Foucault's *I, Pierre Rivière, having slaughtered my mother, my sister, and my brother: A Case of Parricide in the 19th Century* (U of Nebraska, 1982).

'Boy/Analysis (After Melanie Klein's *Narrative of a Child Analysis)*' is, in fact, an abridgement of Klein's classic account. Portions of the text here were used in my video of the same name.

'The Blind Necrophile' is derived from a case study eminent psychoanalyst A. A. Brill (1874–1948) published in the 1920s.

'Death and Sudden Death' is based on Dr. Paul Brouardel's *Death and Sudden Death*, first translated in 1902. Brouardel was a coroner in Paris. A section of this was published in *Cabinet* (Issue 36, Friendship, Winter 2009/2010).

'Notes on My Emigration' was adapted from a panel talk I gave at the conference *Blowing the Trumpet to the Tulips*, organized by Gary Kibbins and Susan Lord (2001, Queens University). The piece was then published in *Public* (25, Experimentalism, Spring 2002).

'Note on My Immigration' is adapted from the voiceover text of the 'Thusly Spåken' section of my video *Hobbit Love is the Greatest Love.*

'Camping (On the Beach)' is a catalogue essay for Doug Ischar's exhibition *Marginal Waters* (Chicago: Golden, 2009).

'End of Analog' is a catalogue essay for the exhibition of the same name, curated by Eric Fleischauer for Roots & Culture (2009, Chicago).

'Incidents of Travel" is based on John L. Stephen's Victorian classic *Incidents of Travel in the Yucatan*, Vols. I and II.

'Not Torn (Asunder from the Very Start)' is a chunk of voiceover text from the eponymous video. The video was produced as part of SAW Video's "Public Domain" through the Canada Council's Media Arts Commissioning Program, in participation with the National Library and Archive.

'My Life (With Duke and Battersby)' was commissioned by Mike Hoolboom for an online publication he put together on the occasion of the Duke/Battersby retrospective screening at the International Film Festival Rotterdam. (It is hoped a paper version of the publication will be available soon.)

Special thanks to Mike Hoolboom, who was the prime force in causing many of these writings – and so many more! by me and others! so many others! – to come into existence.

About the Author

Steve Reinke is an artist and writer best known for his monologue-based videos, which include *The Hundred Videos*, *Spiritual Animal Kingdom*, *Anal Masturbation and Object Loss* and *Anthology of American Folk Song*. His work has been exhibited at such venues as the Museum of Modern Art, National Gallery of Canada, the Power Plant, Tate Modern, Centre Pompidou, Sundance and the International Film Festival Rotterdam. He has co-edited several anothologies, including *Lux: A Decade of Artists' Film and Video* (with Tom Taylor) and *The Sharpest Point: Animation at the End of Cinema* (with Chris Gehman). His book, *Everybody Loves Nothing: Scripts 1996–2004*, was also published by Coach House. In 2006 he was awarded the Bell Award in Video Art. He is currently associate professor in Art Theory and Practice at Northwestern University. His website is www.myrectumisnotagrave.com

Typeset in Bell MT
Printed and bound at the Coach House on bpNichol Lane, 2011

Edited by Anthony Elms and Alana Wilcox
Design by Alana Wilcox
Cover art by The Lions (James Whitman, Barry Doupé, Tasha
 Brotherton, Collin Johanson and Matthew Brown), courtesy of
 the artists, www.lionspile.ca

|GALLERY| **400**

Coach House Books
80 bpNichol Lane
Toronto ON
M5S 3J4
Canada

416 979 2217
800 367 6360

mail@chbooks.com
www.chbooks.com

Gallery 400
University of Illinois at Chicago
400 South Peoria St. (MC034)
Chicago, IL 60607
USA

312 996 6114

uicgallery400@gmail.com
http://gallery400.aa.uic.edu